The Drawings from John Magic

By John Magic

The Drawings from John Magic

Copyright © 2019 John Magic All rights reserved.

Published by M.J. Magic Publishing on Amazon.com. This publication is protected by copyright, and permission must be obtained from the author prior to any prohibited reproduction, storage in a retrieval system, or transmission in any form or by any means, electronic, mechanical, photocopying, recording, or likewise. To obtain permission to use material from this work, please submit a written request to Mr. John Magic:

mark.john.magic@gmail.com.

ASIN: B07QPN3NJ1 (eBook)

ISBN-13: 978-1093974690 (Paperback)

ISBN-10: 1093974690 (Paperback)

First Edition: April 2019

Chapter 1: Colored Drawings

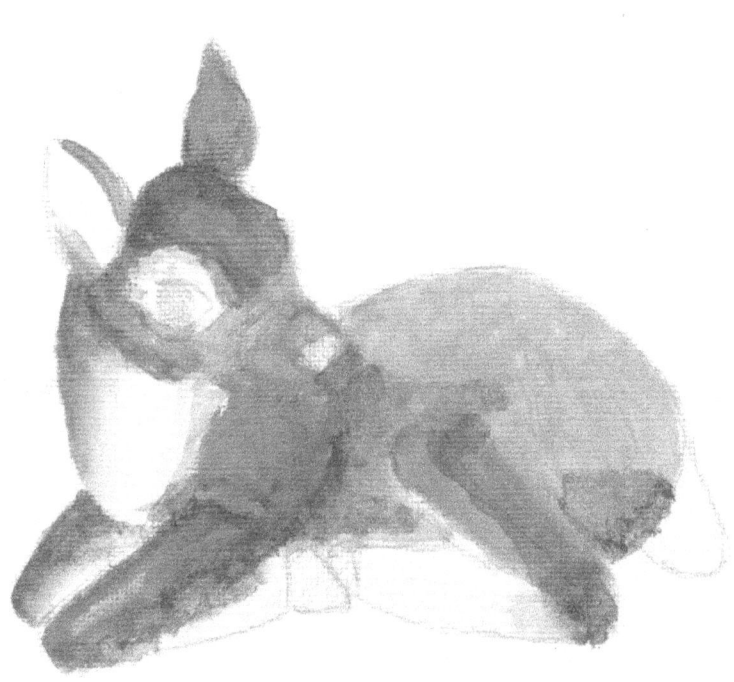

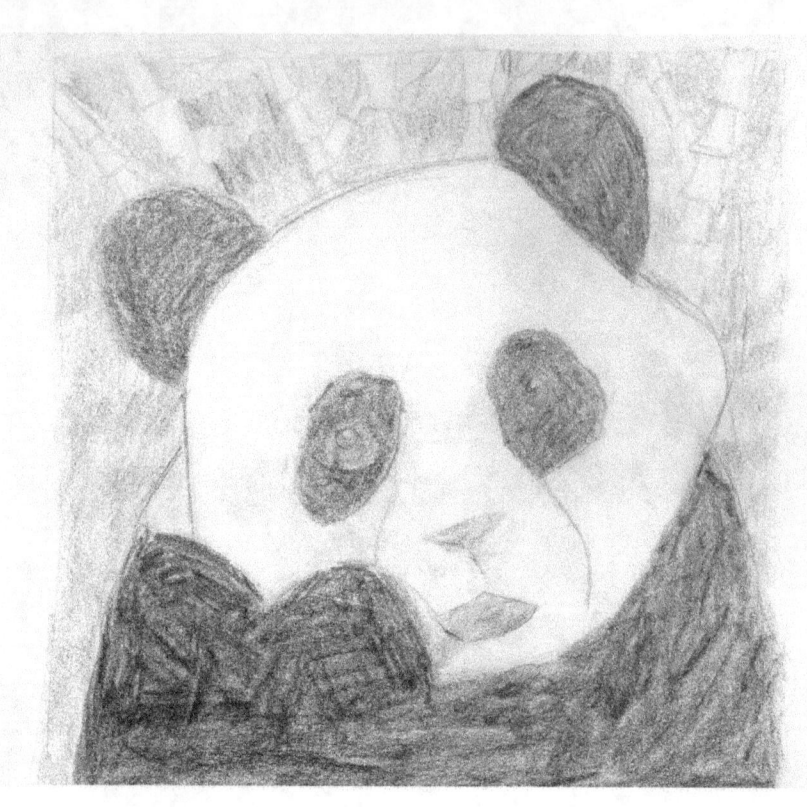

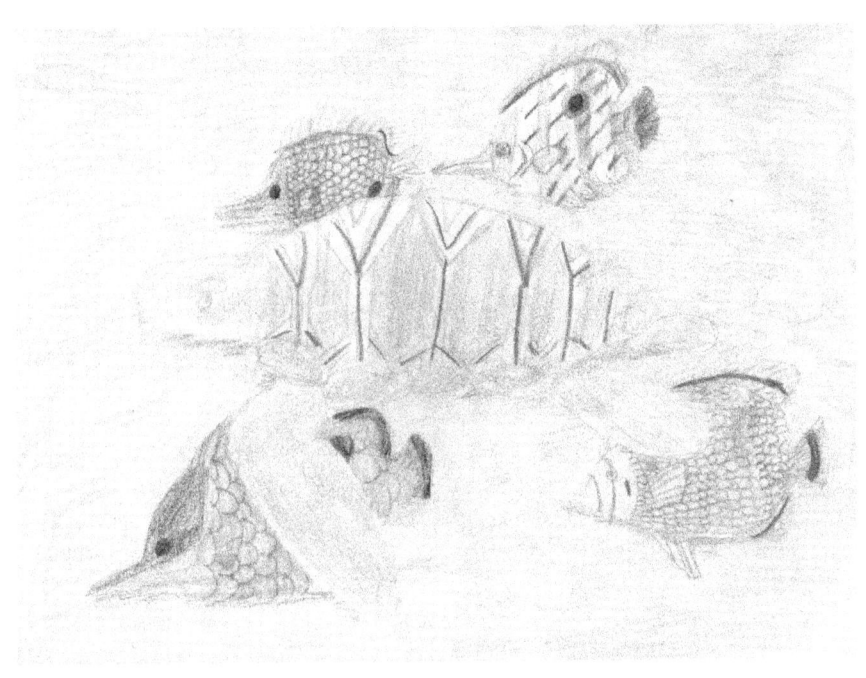

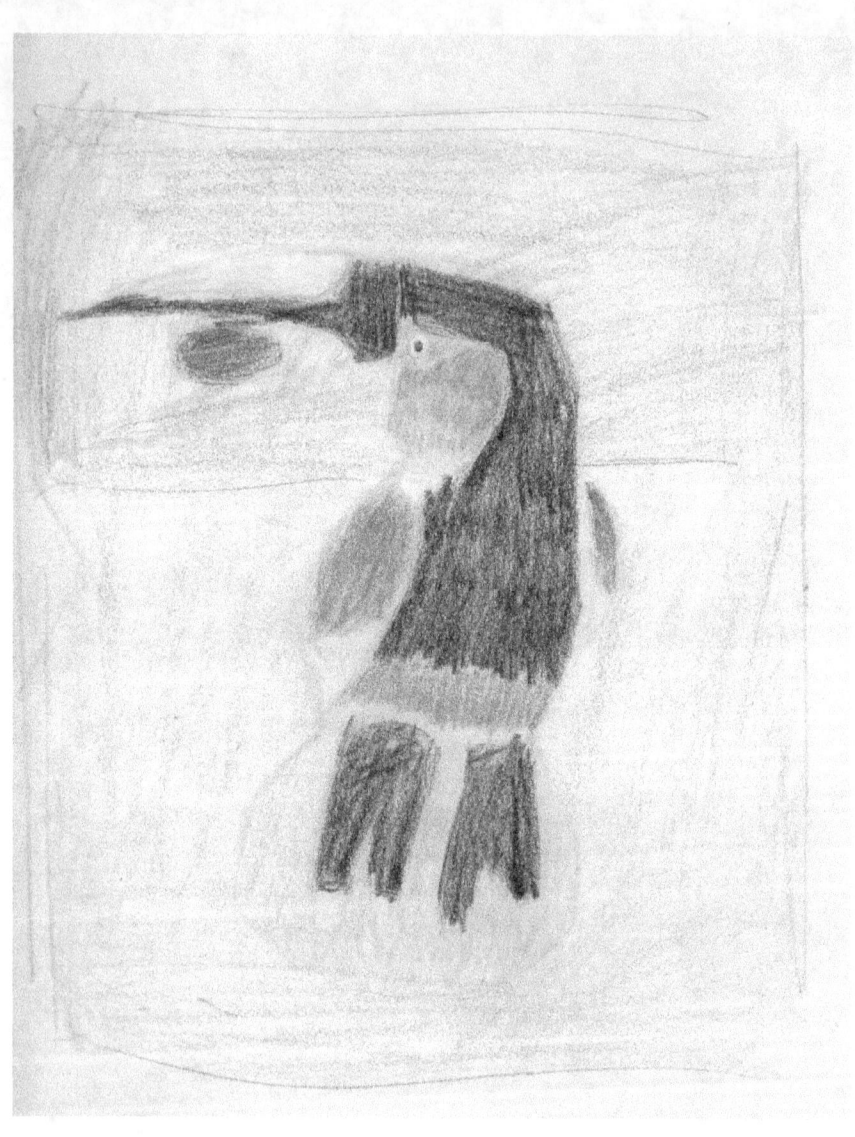

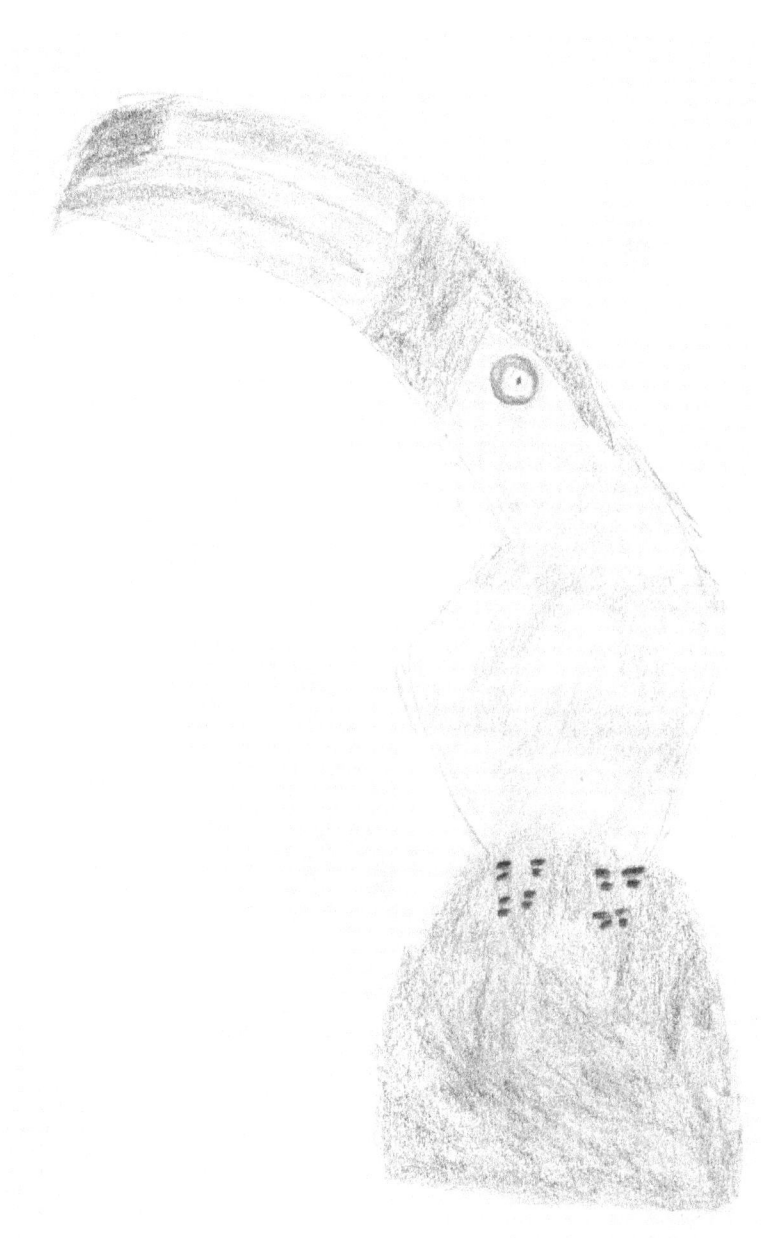

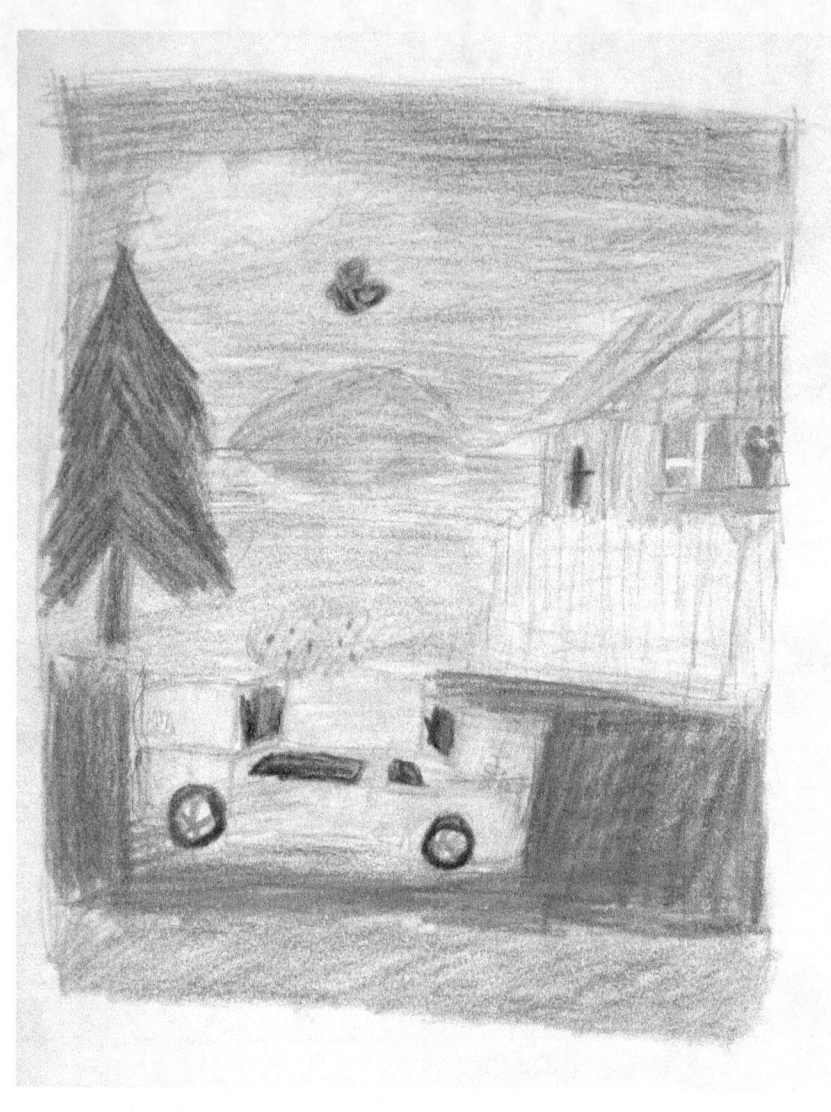

Chapter 2: Animal Drawings

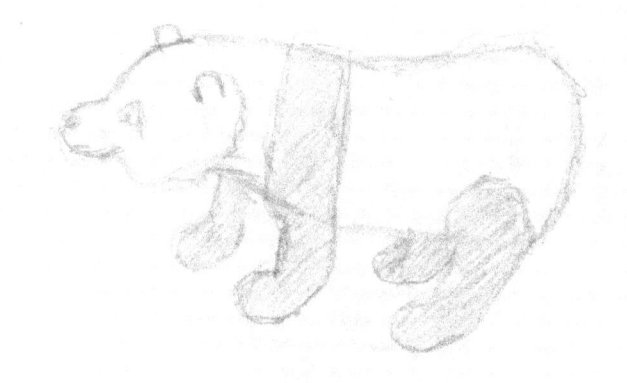

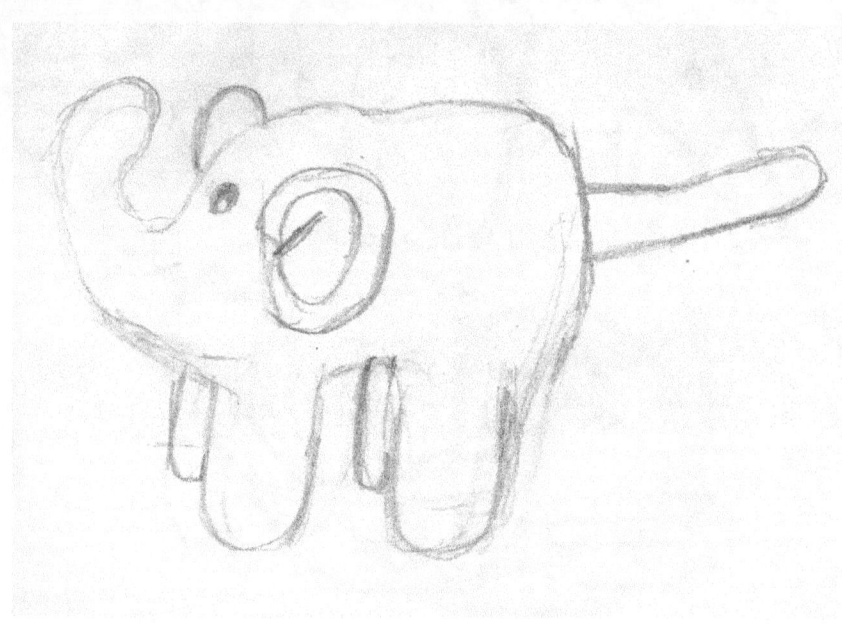

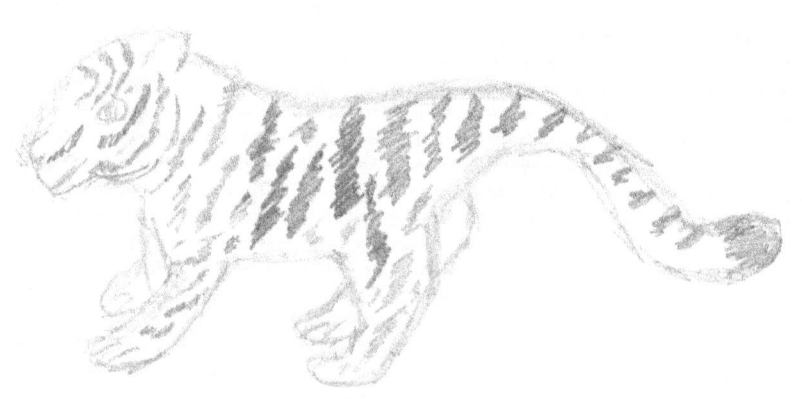

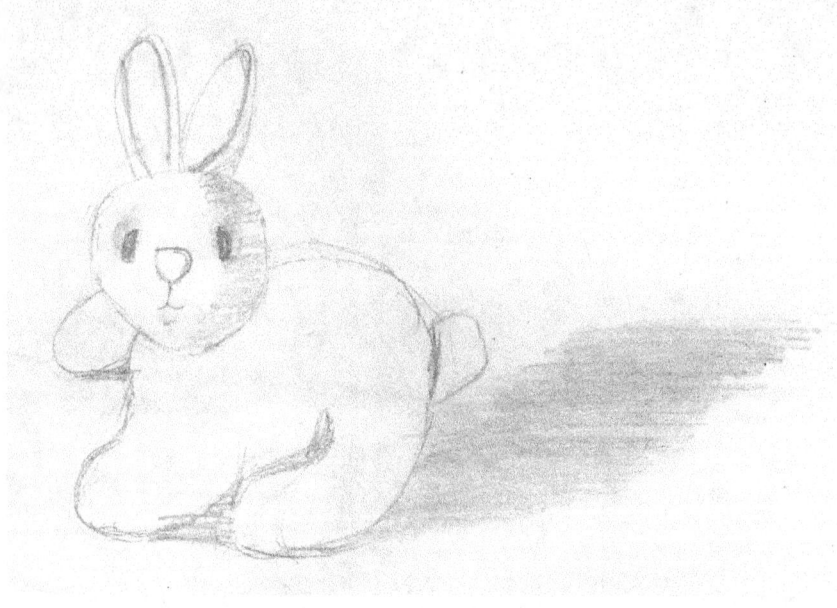

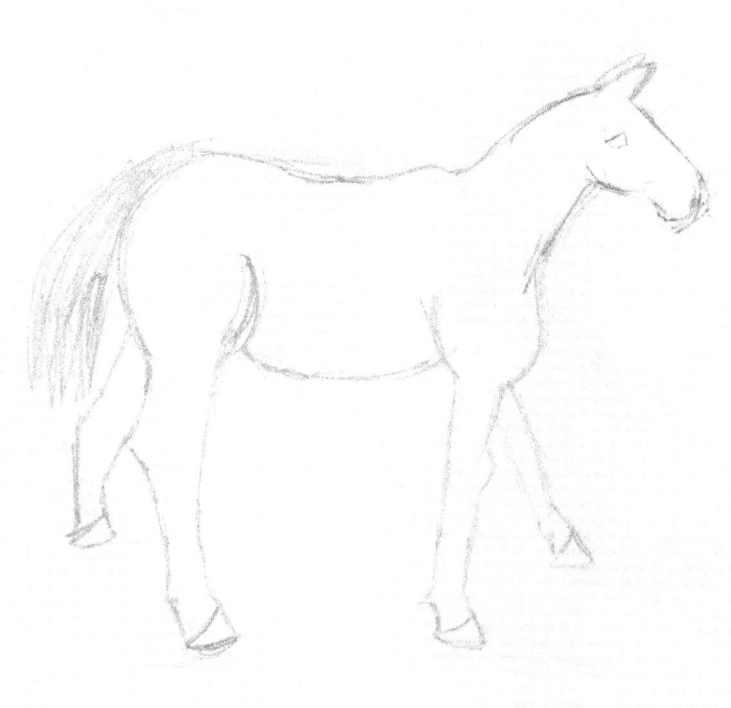

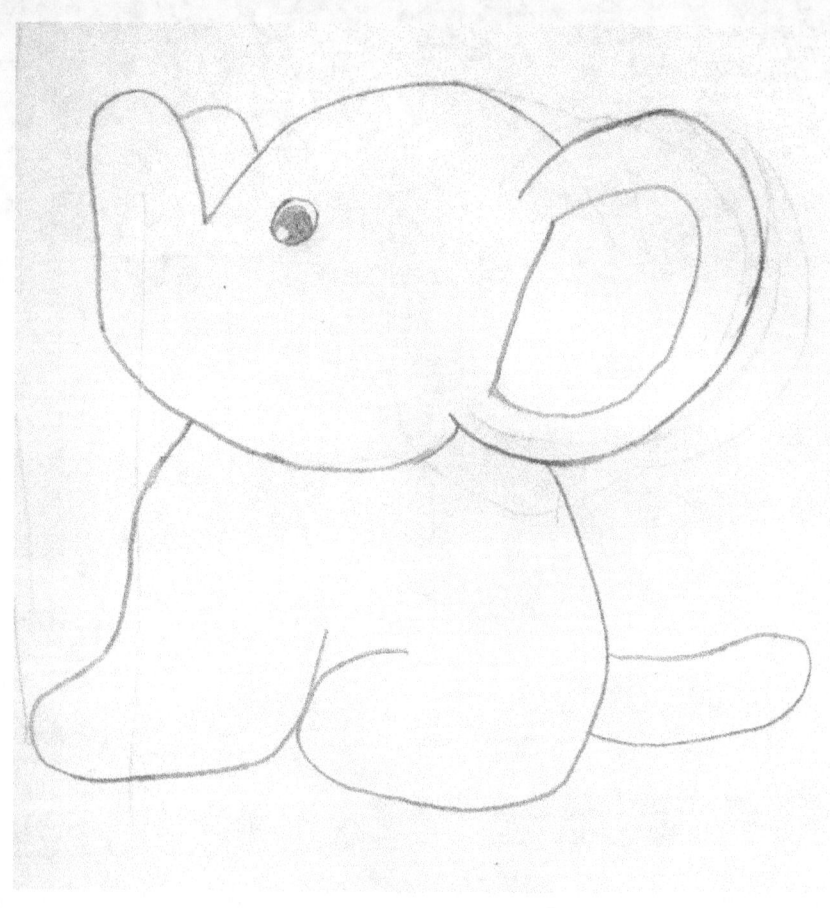

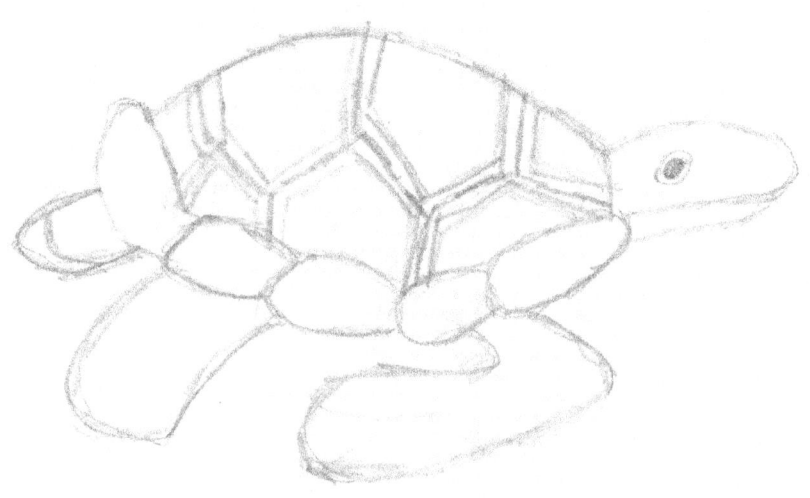

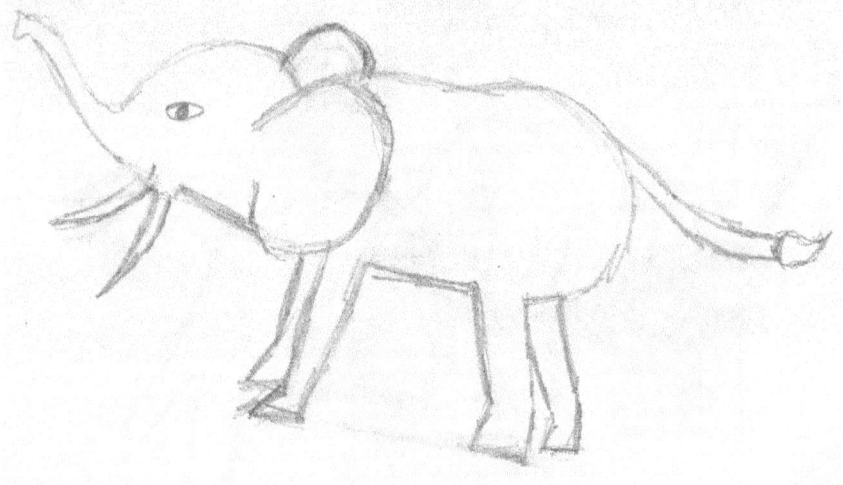

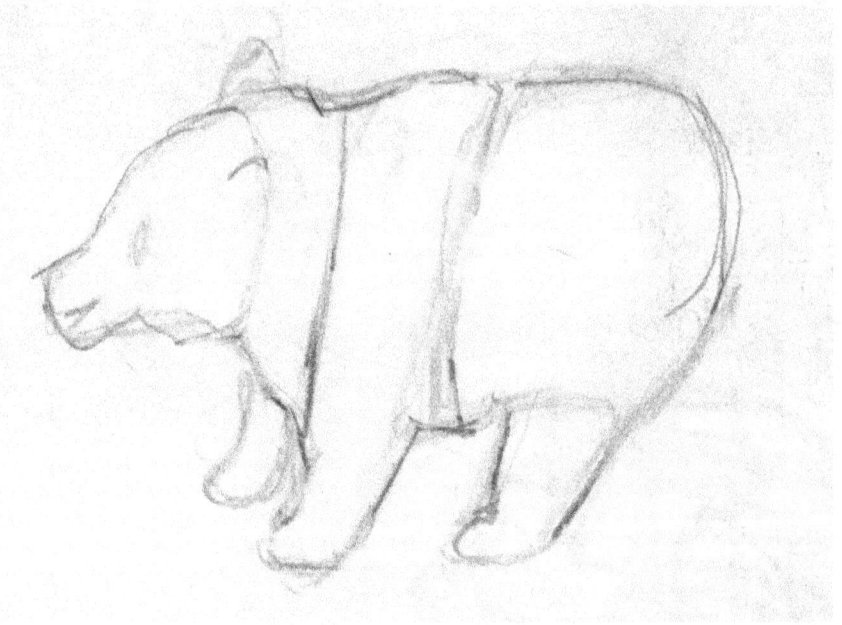

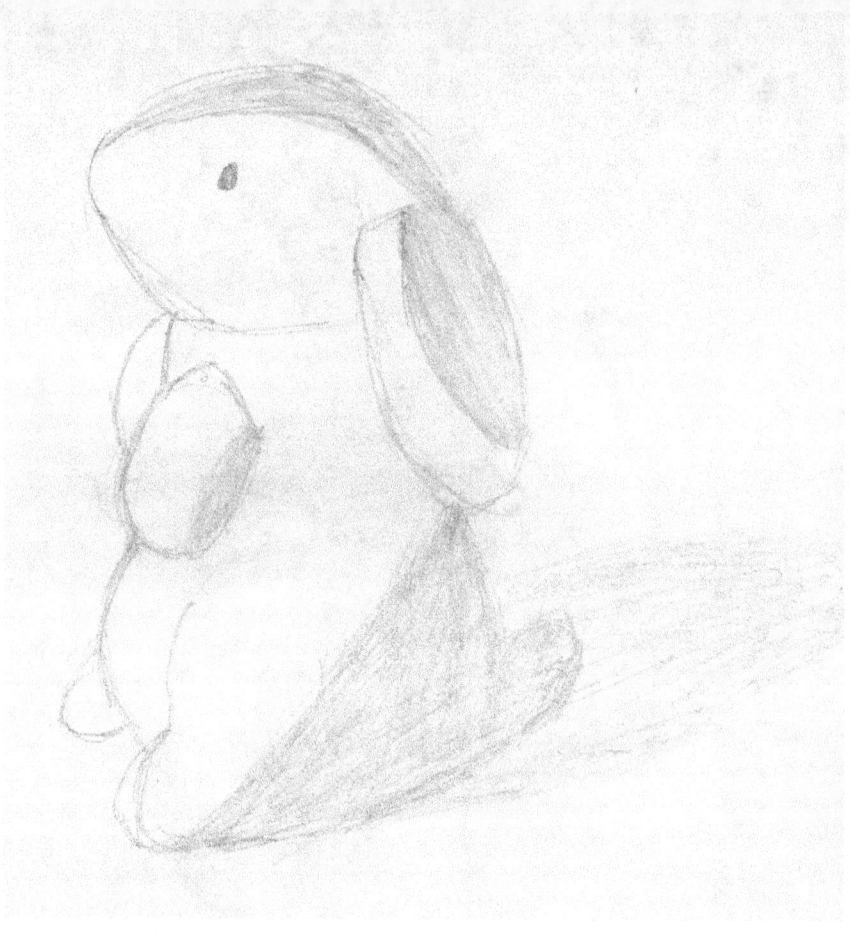

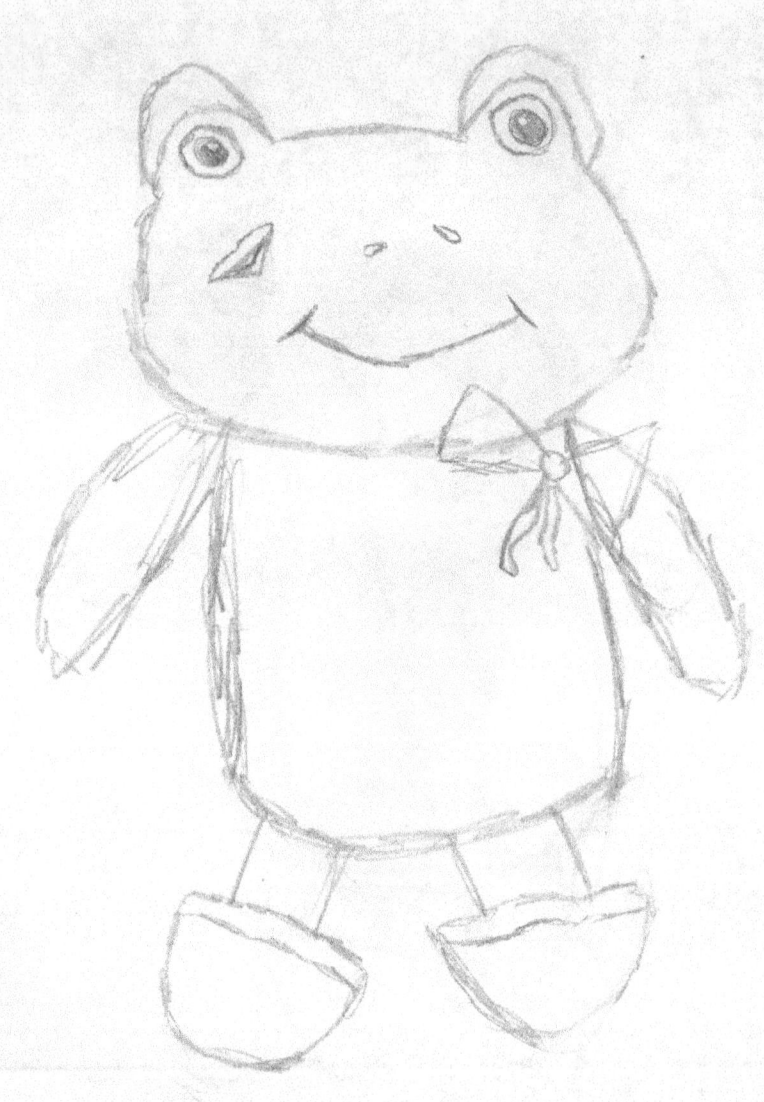

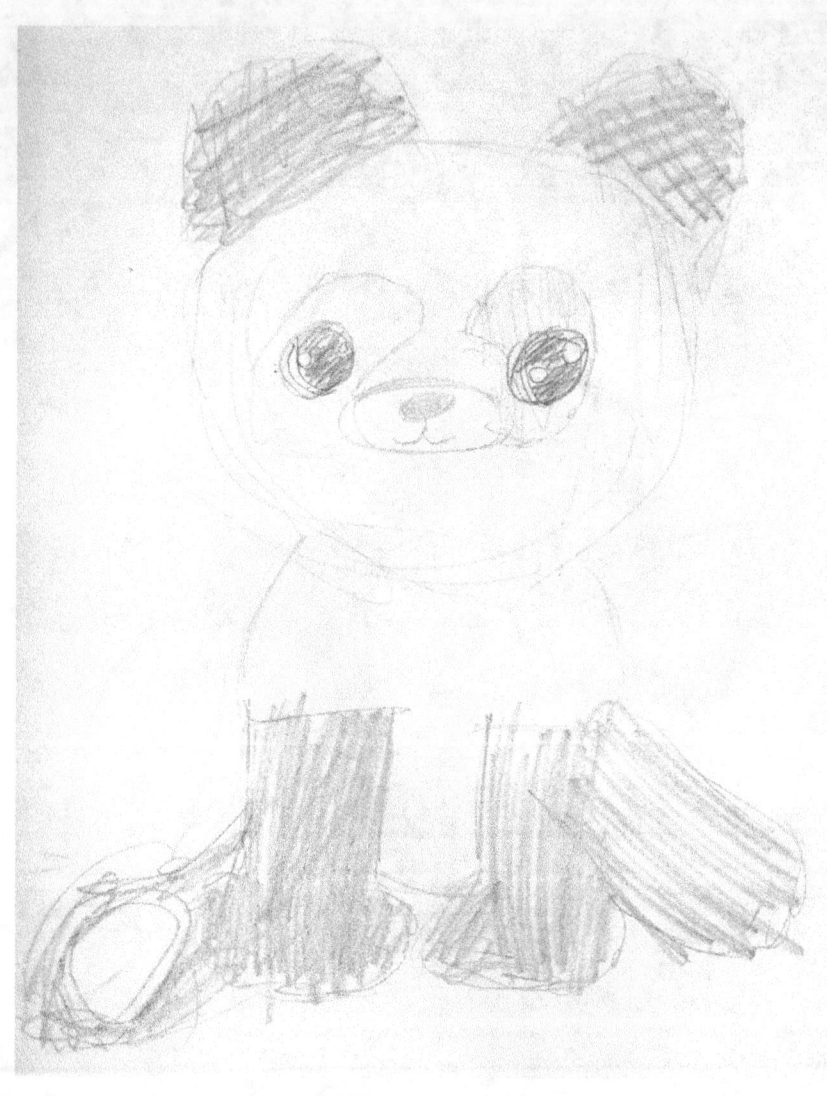

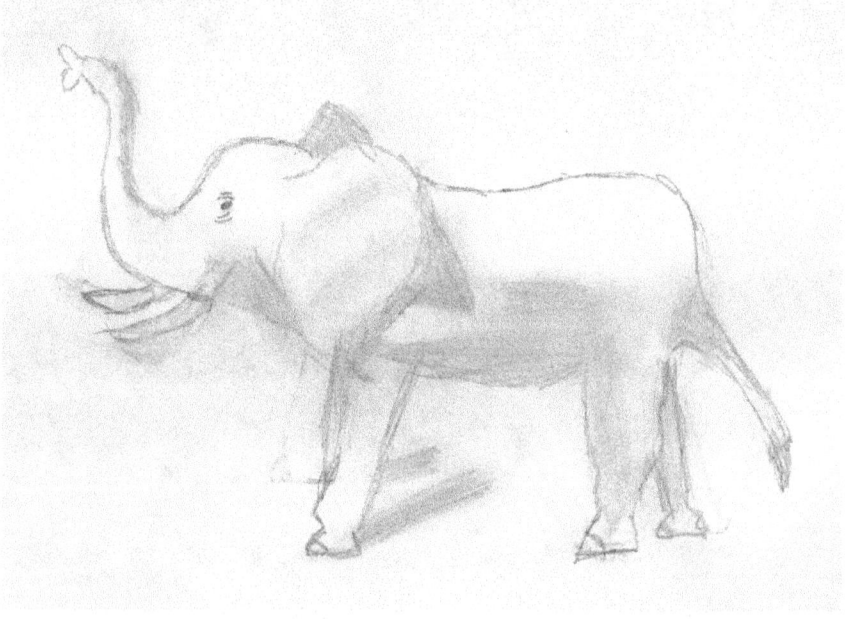

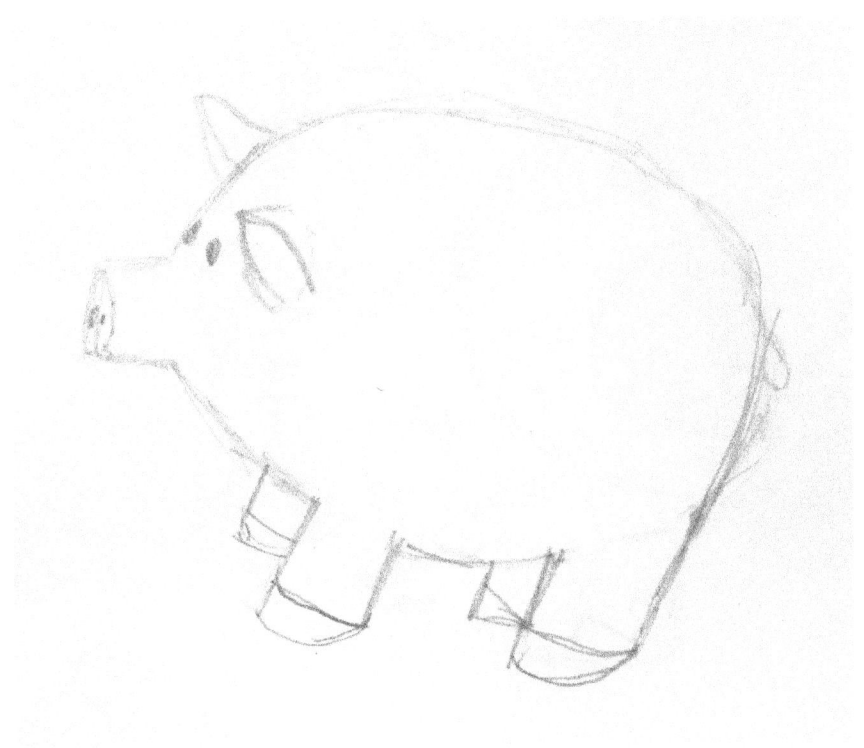

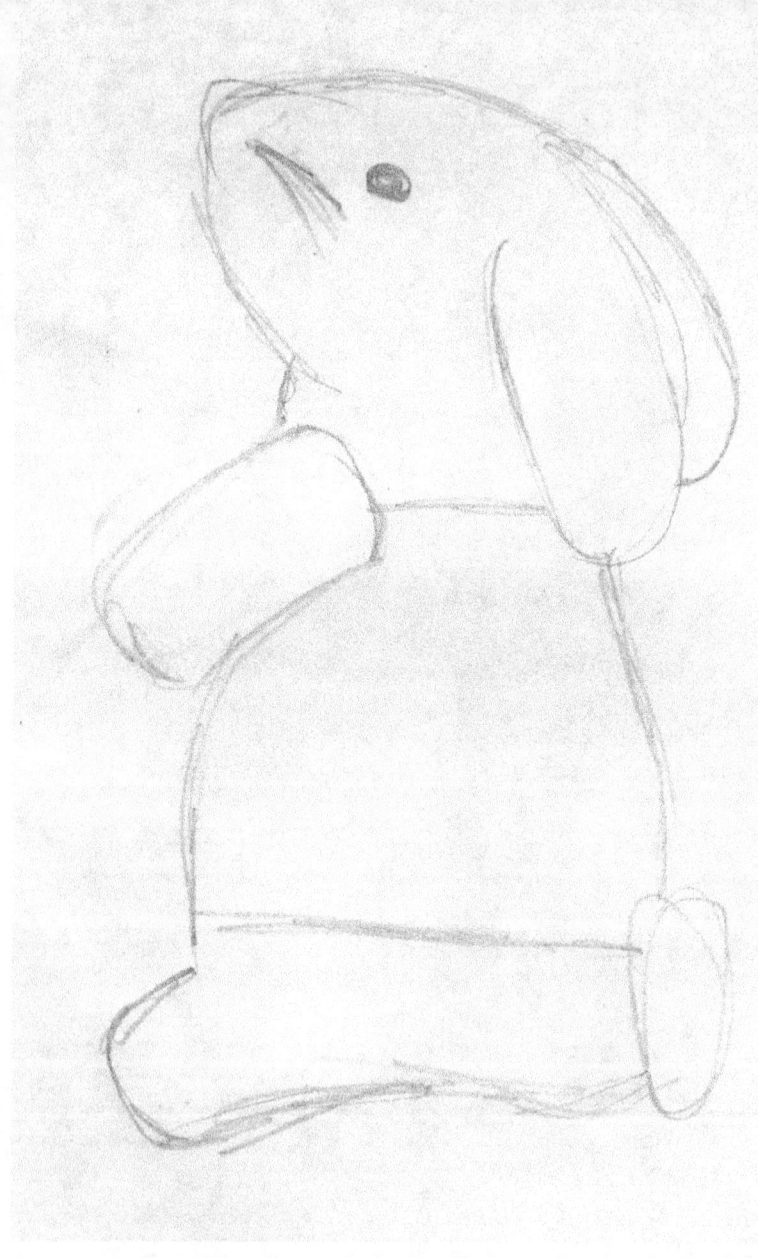

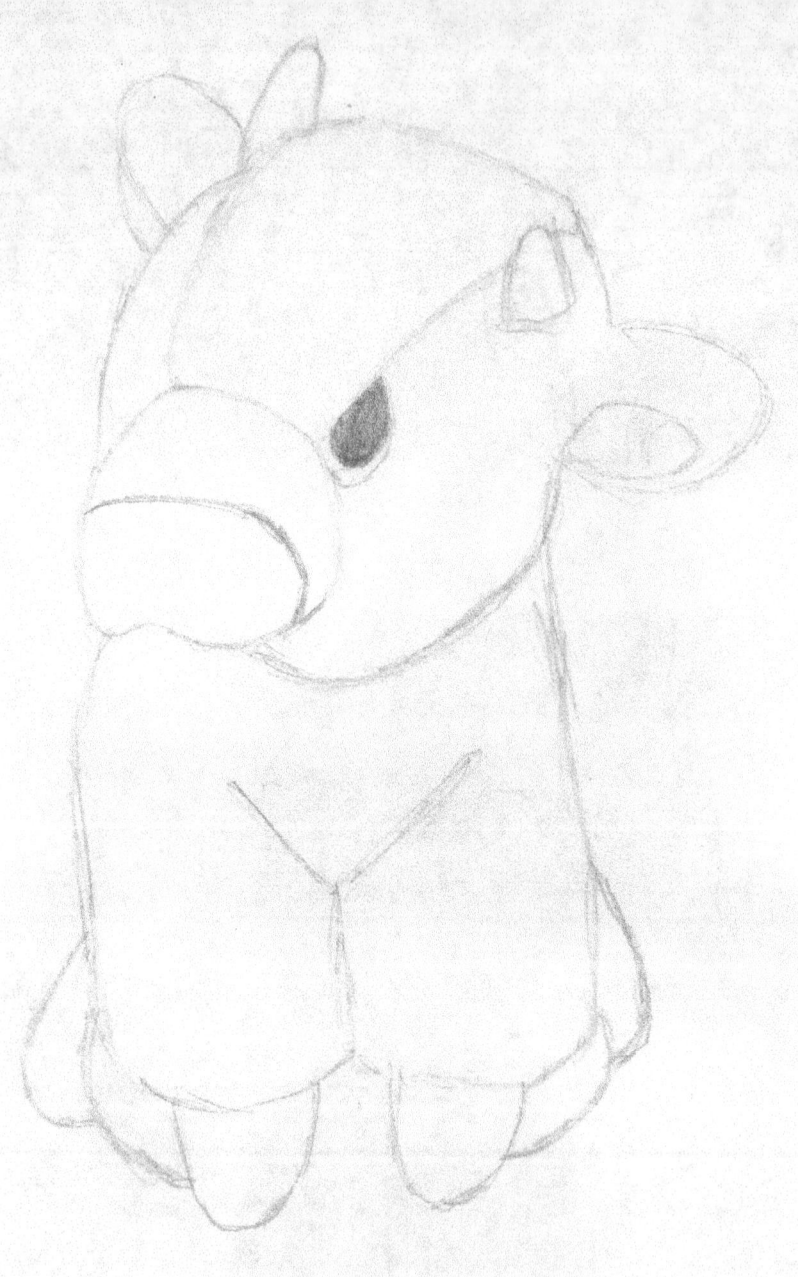

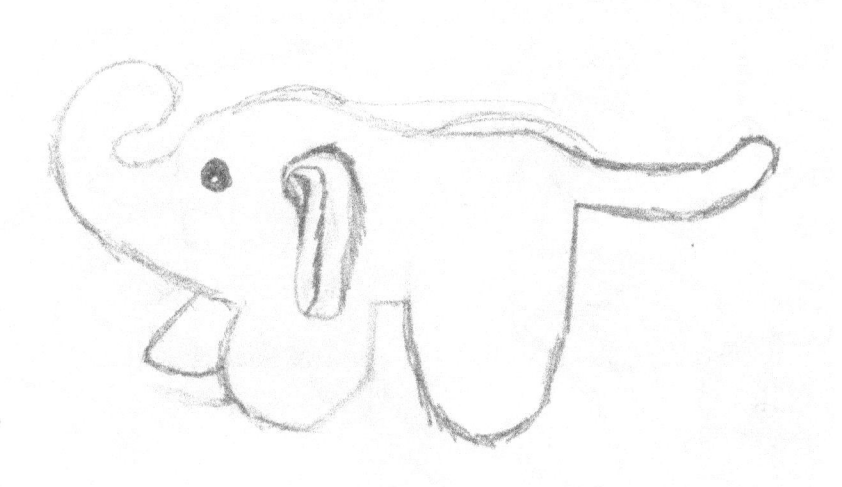

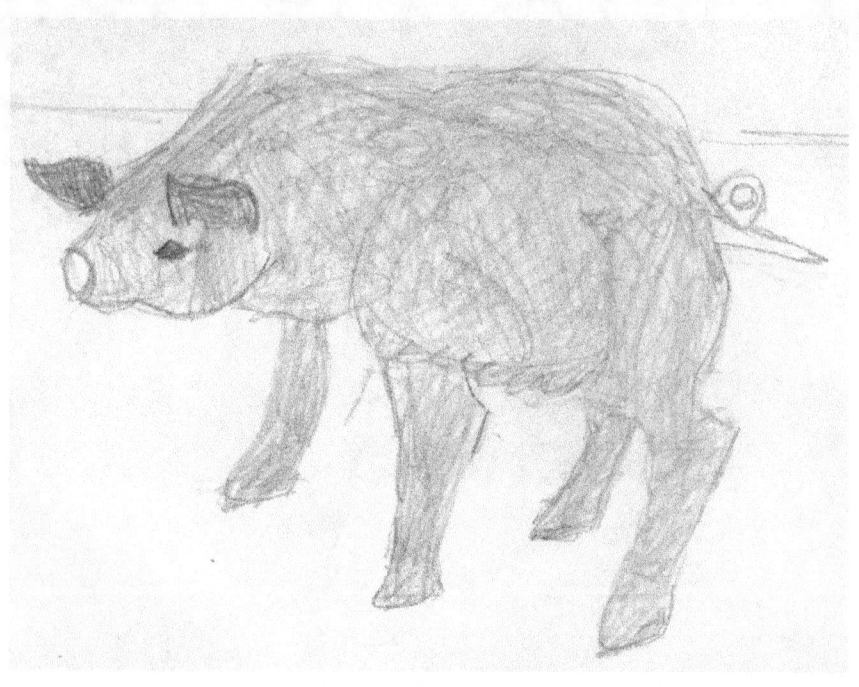

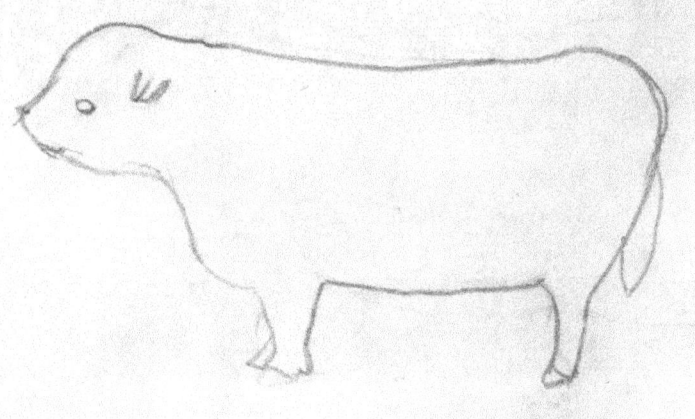

Chapter 3: Bird Drawings

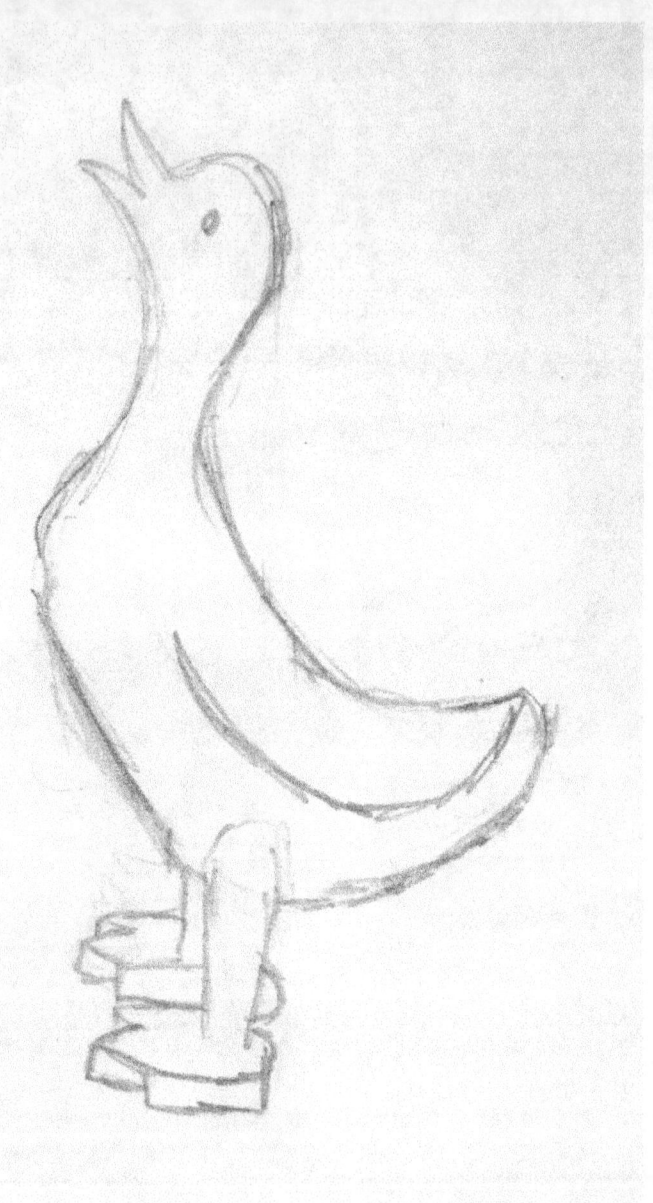

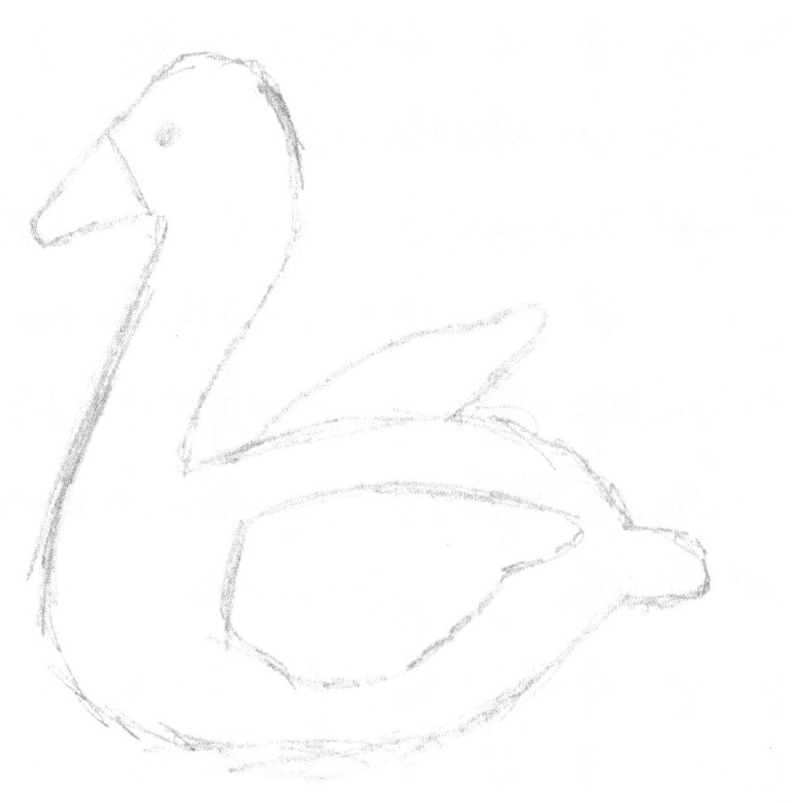

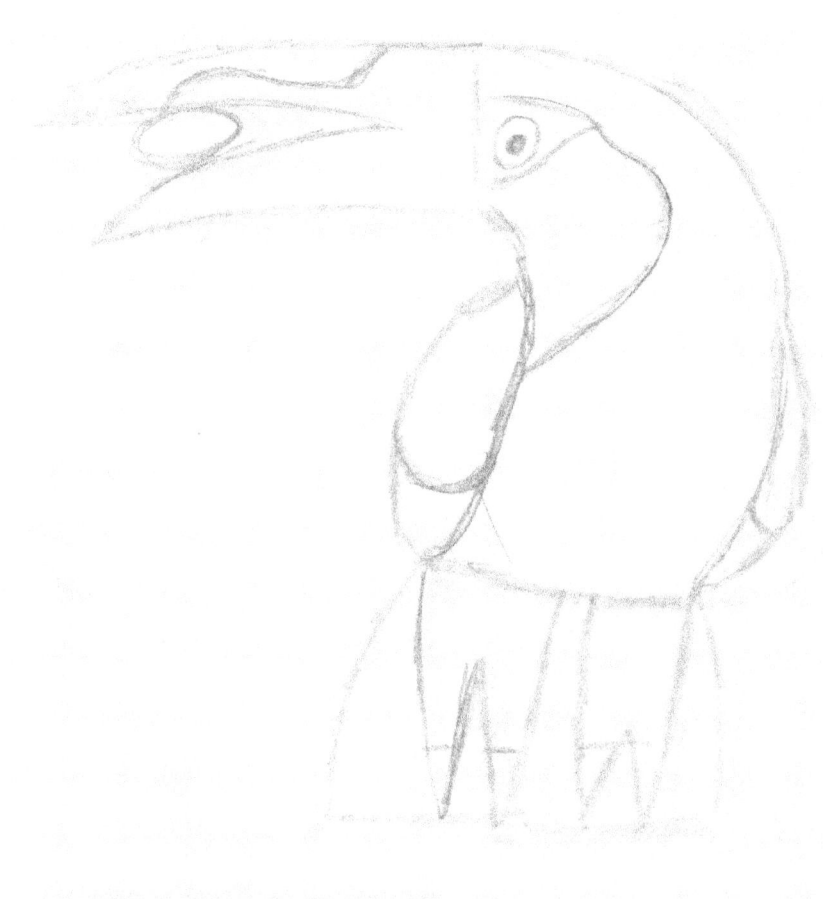

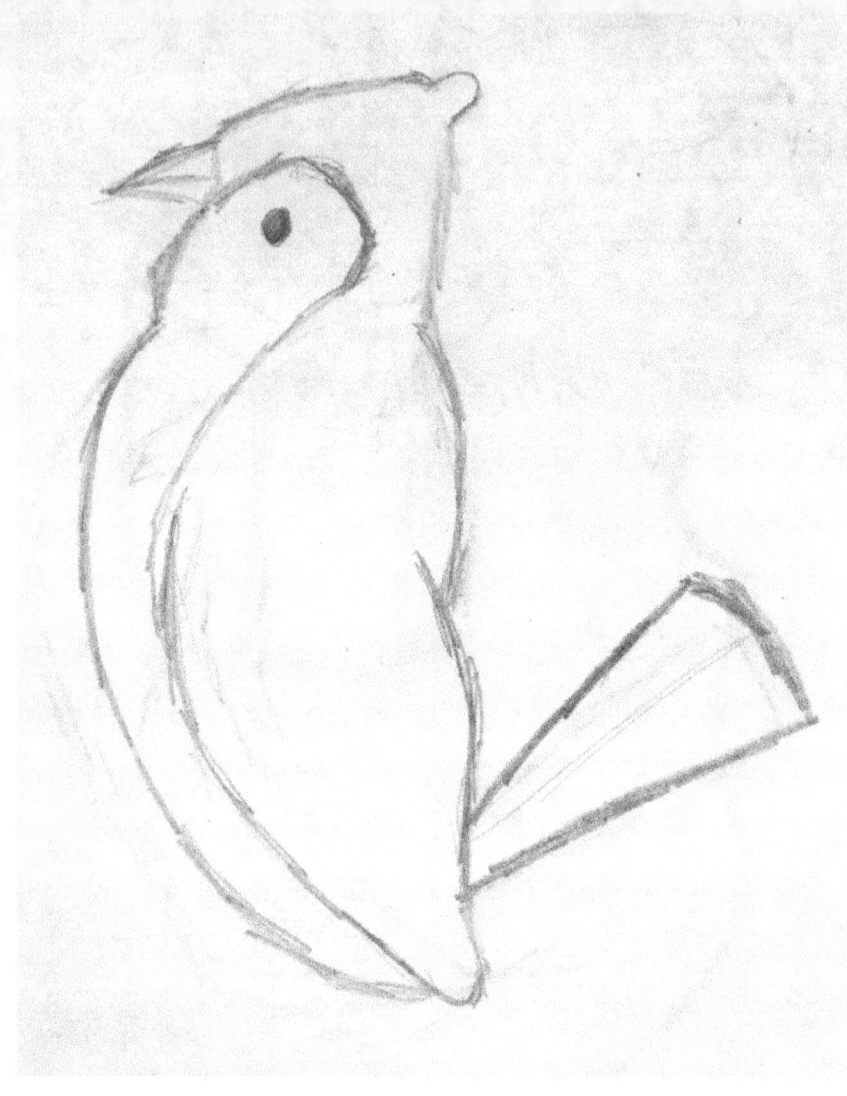

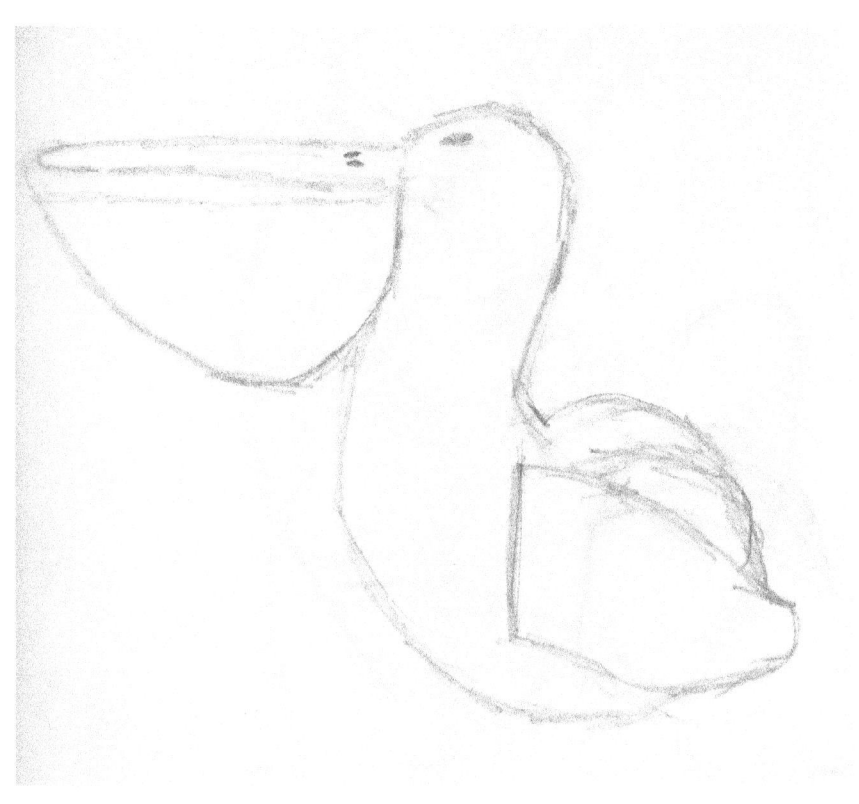

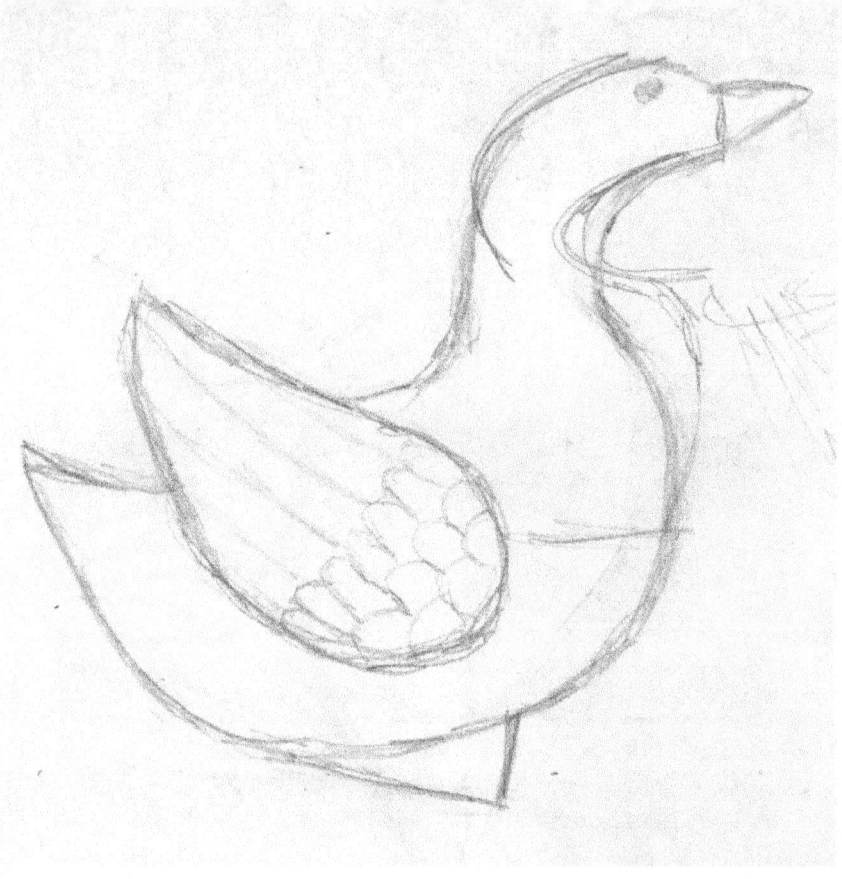

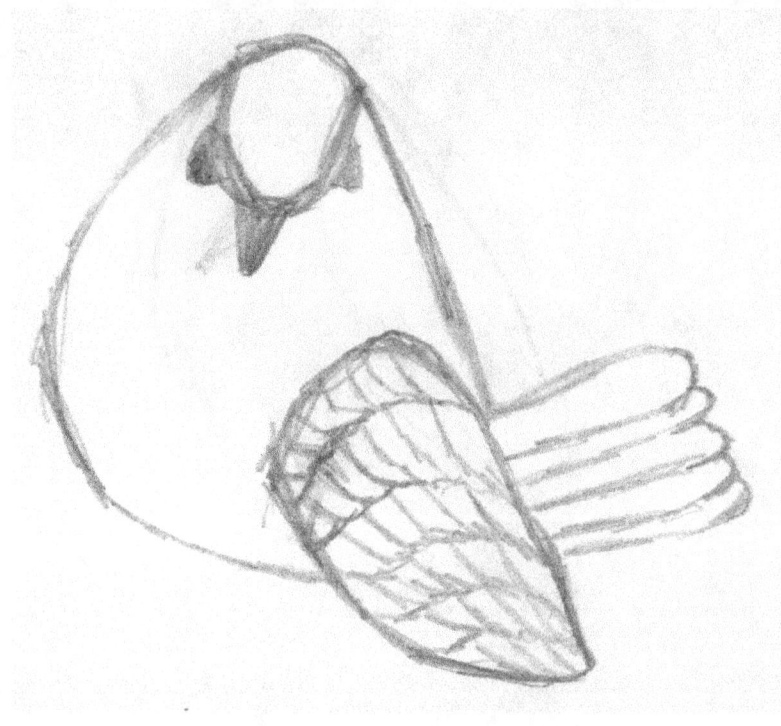

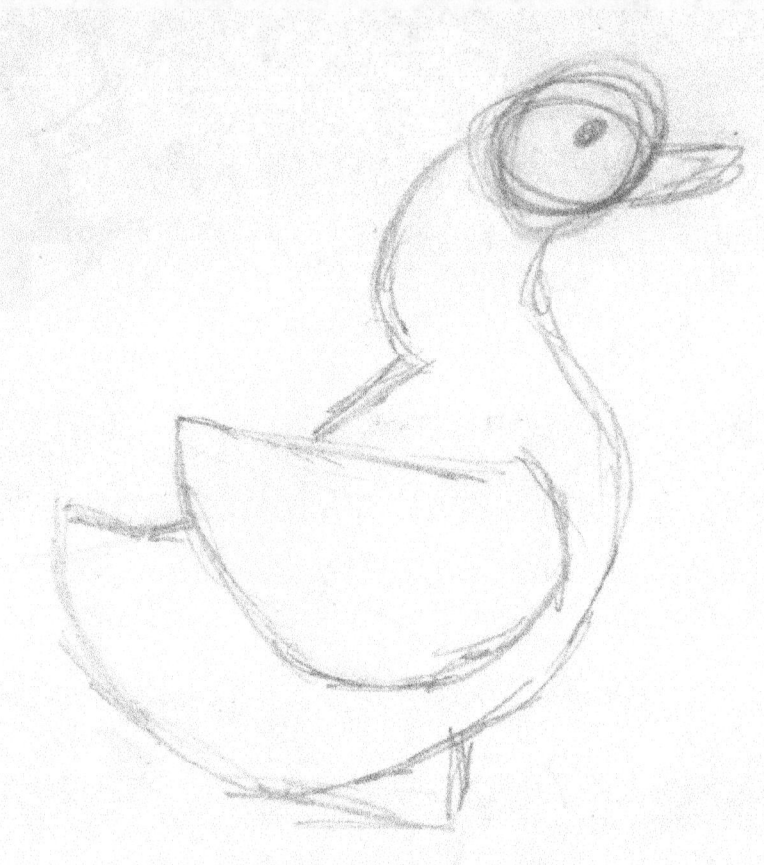

Chapter 4: Object Drawings

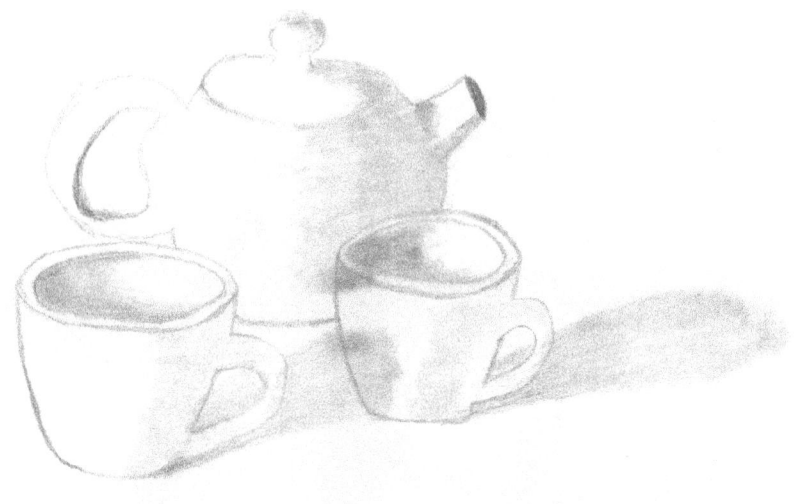

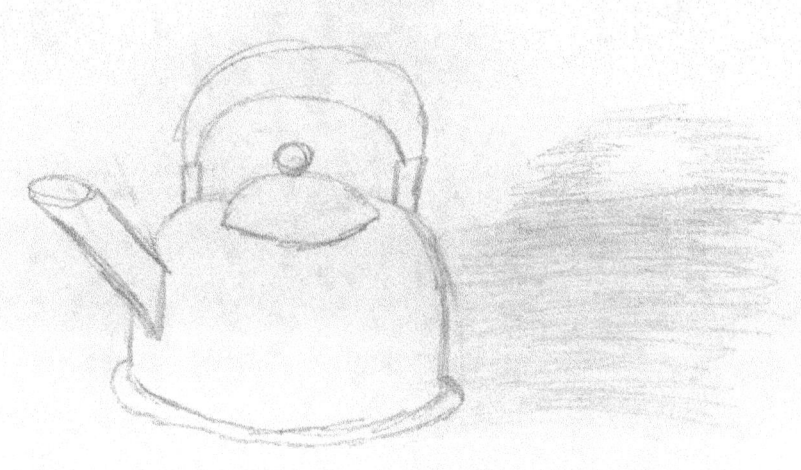

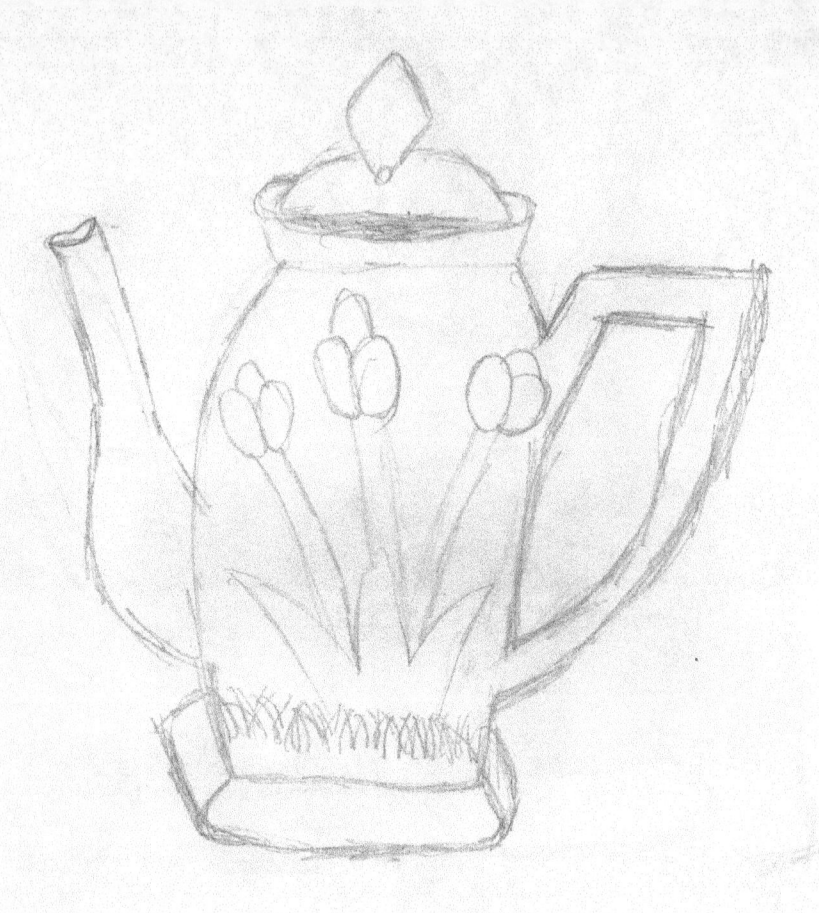

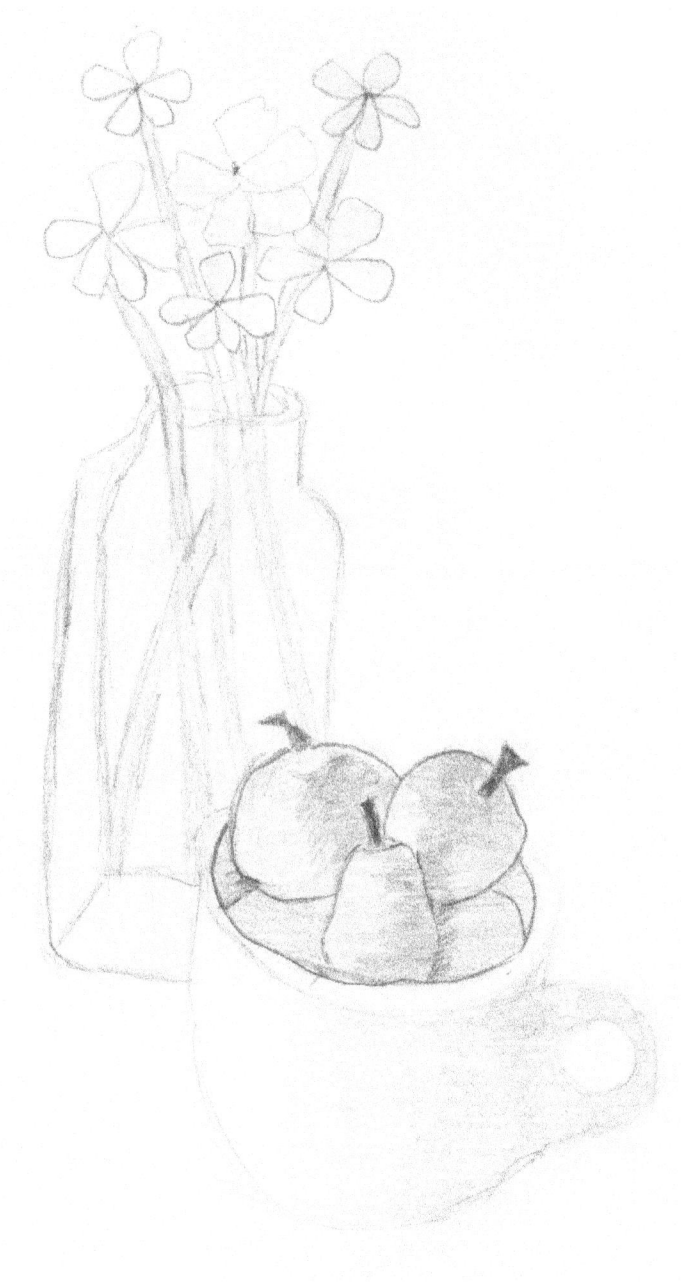

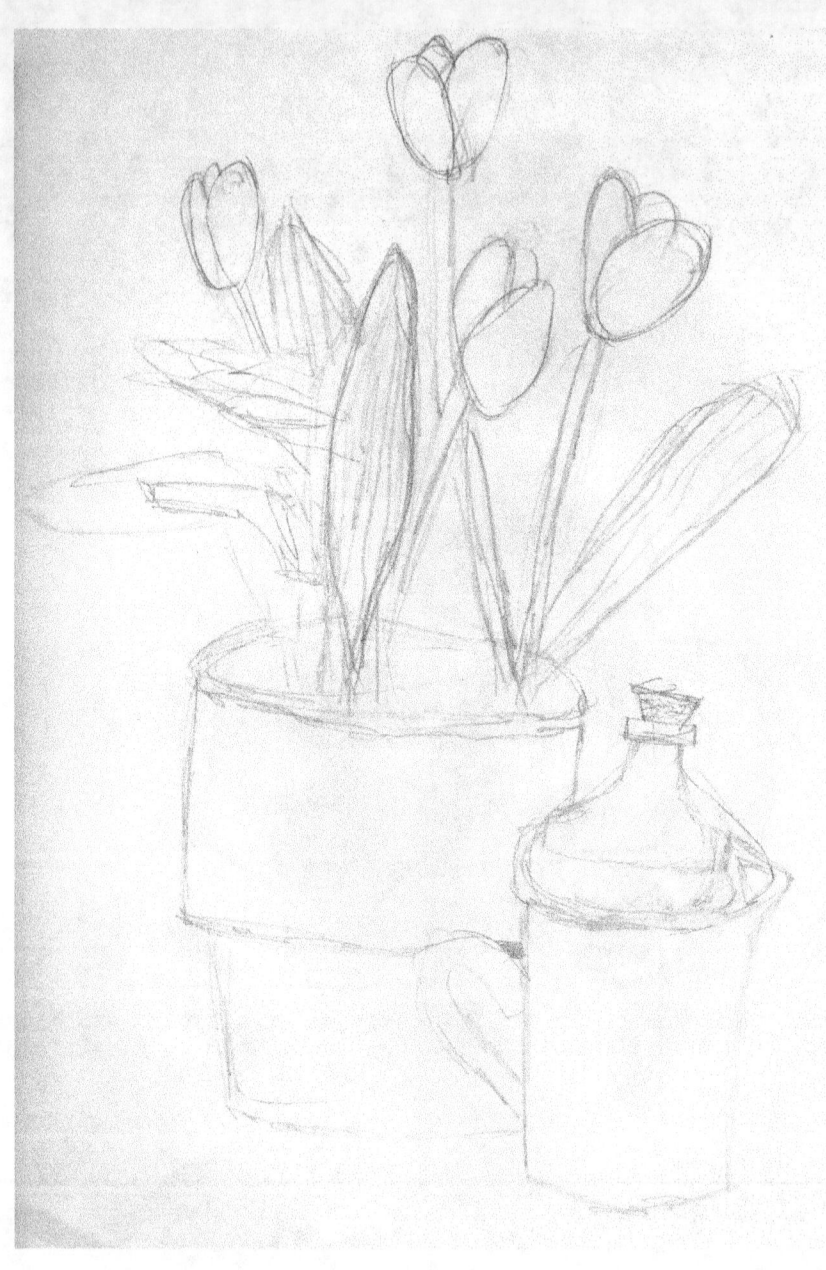

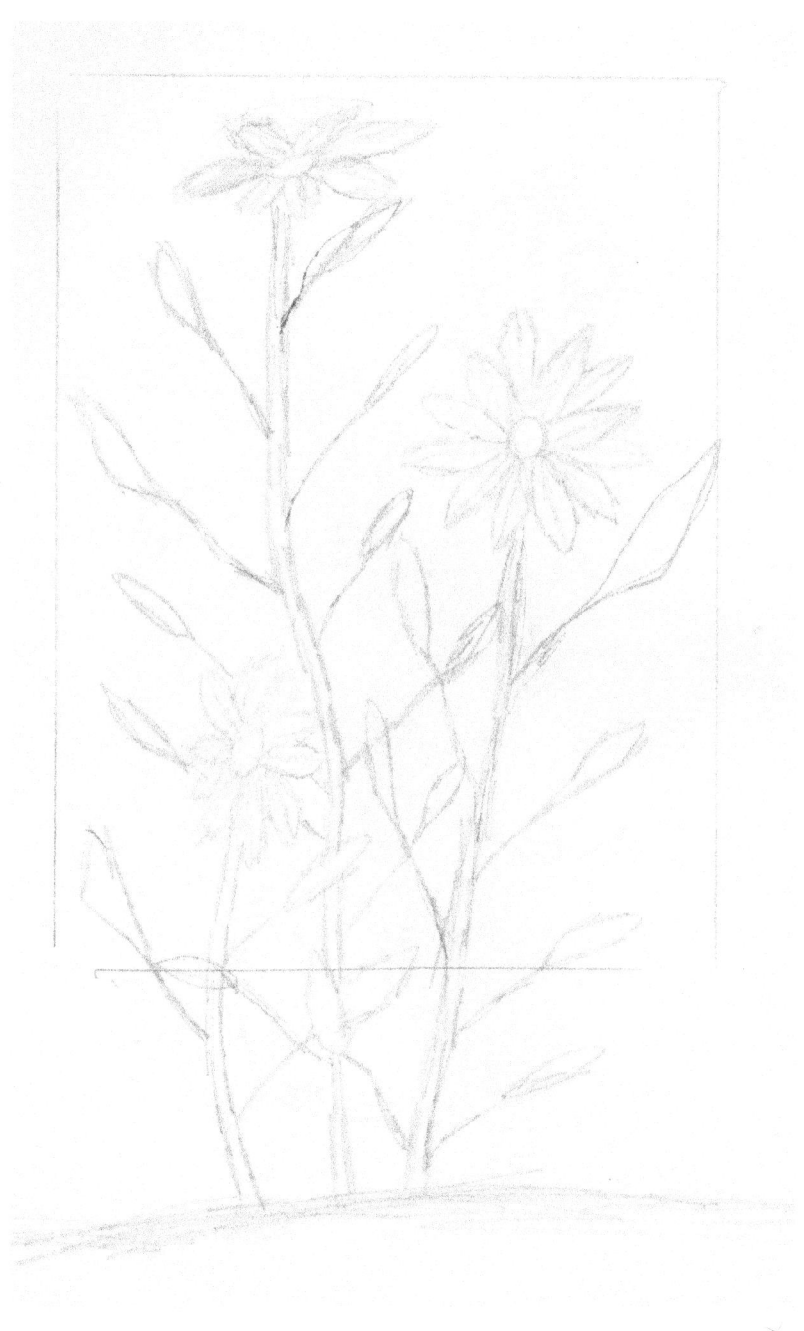

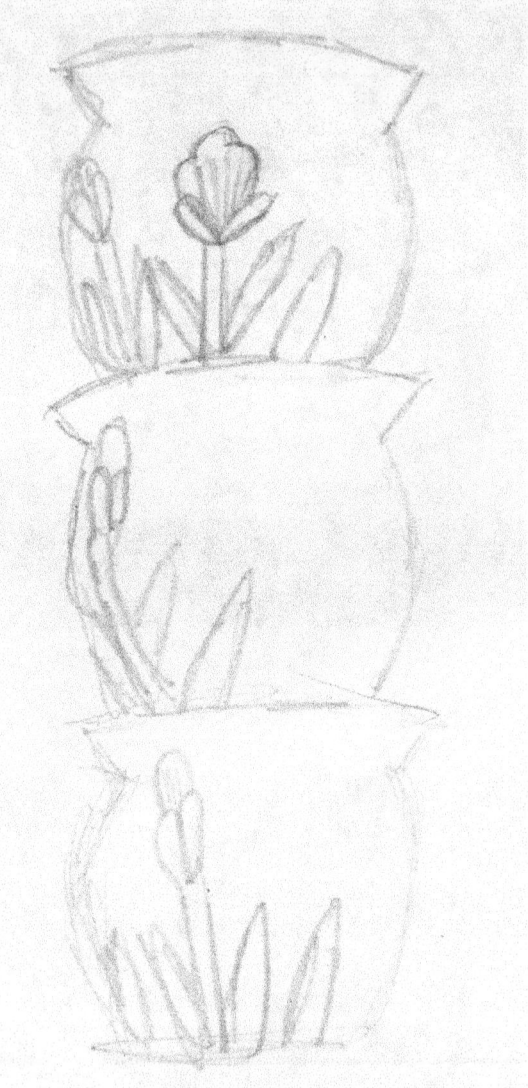

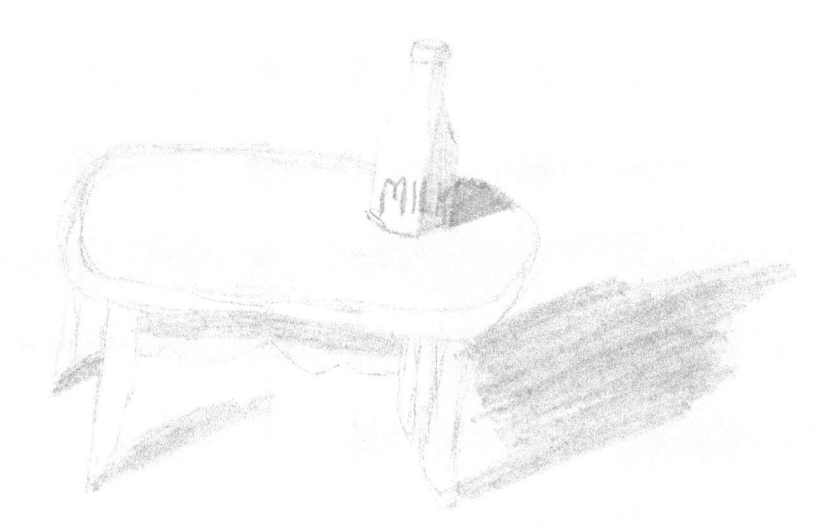

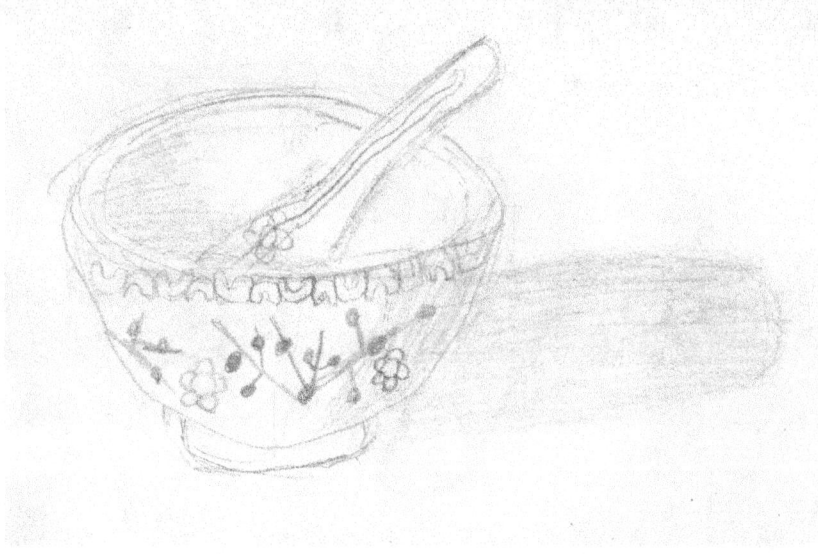

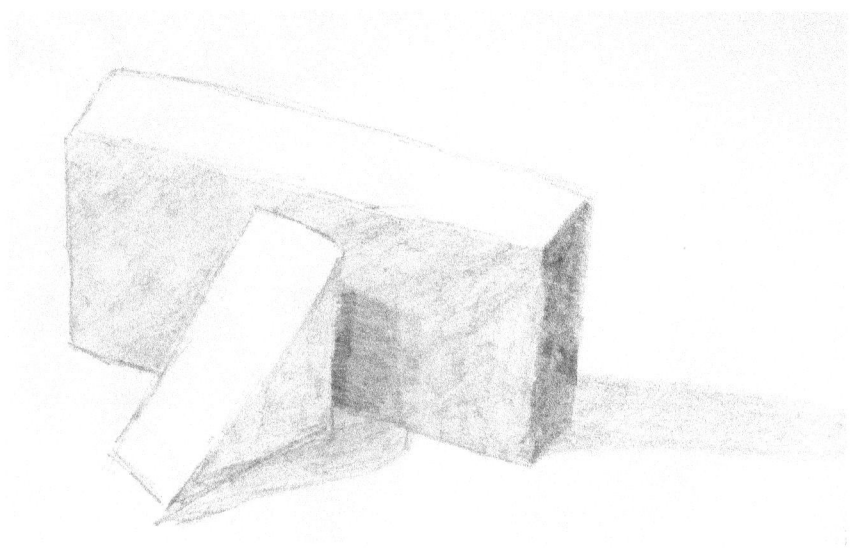

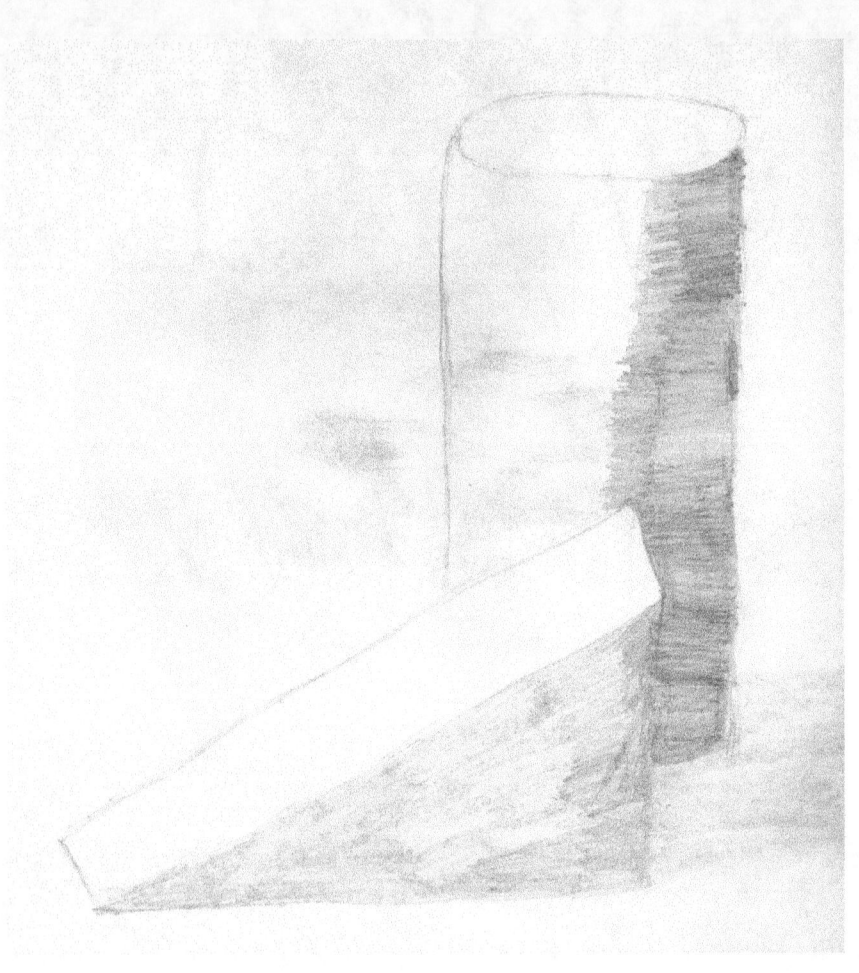

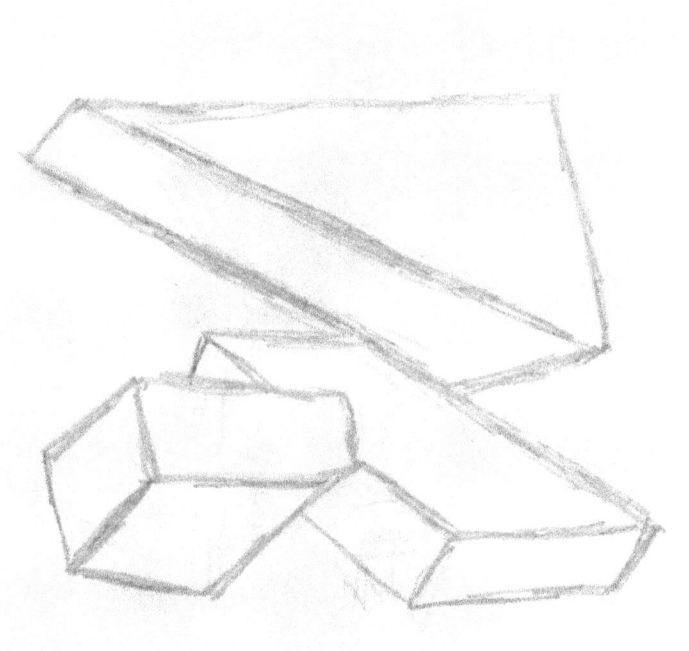

Chapter 5: Combined Drawings

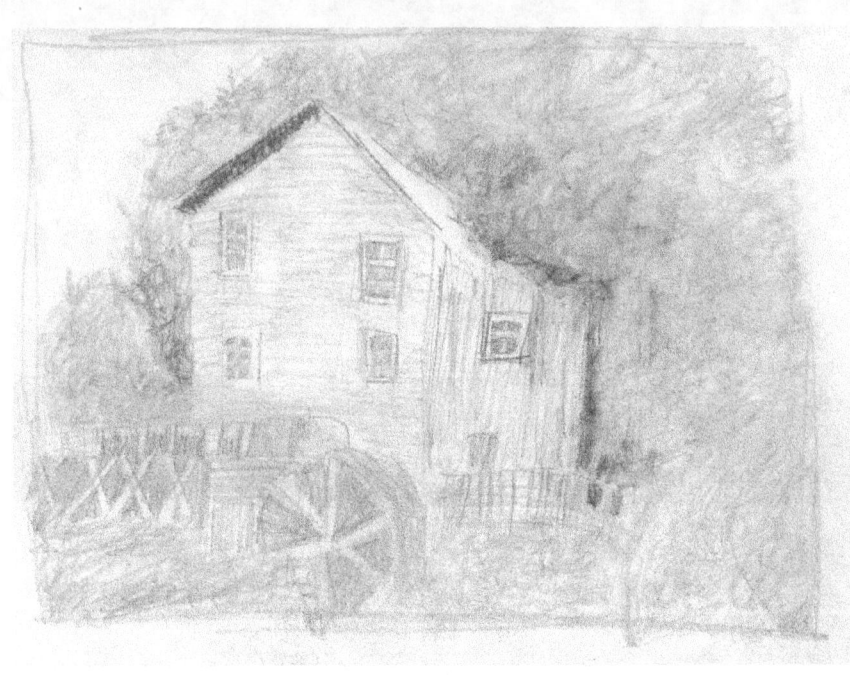

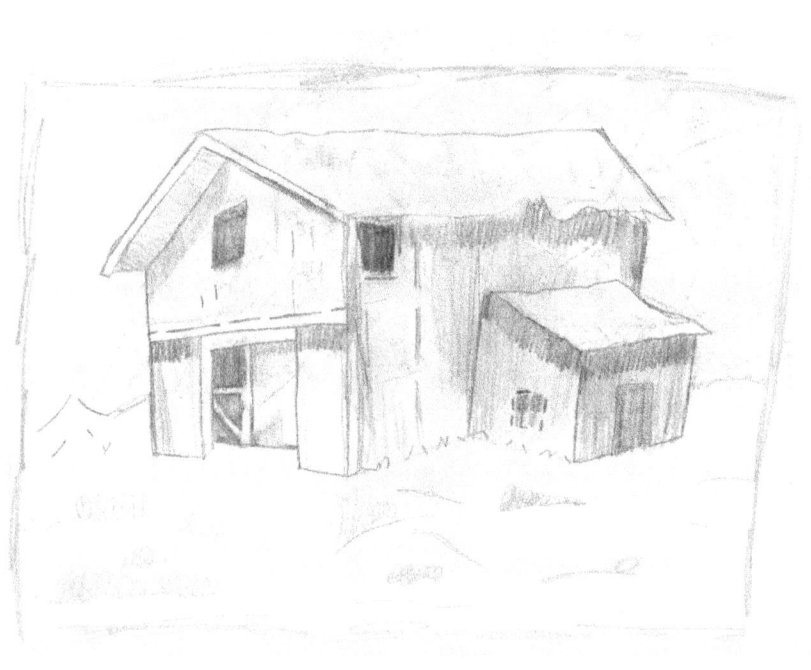

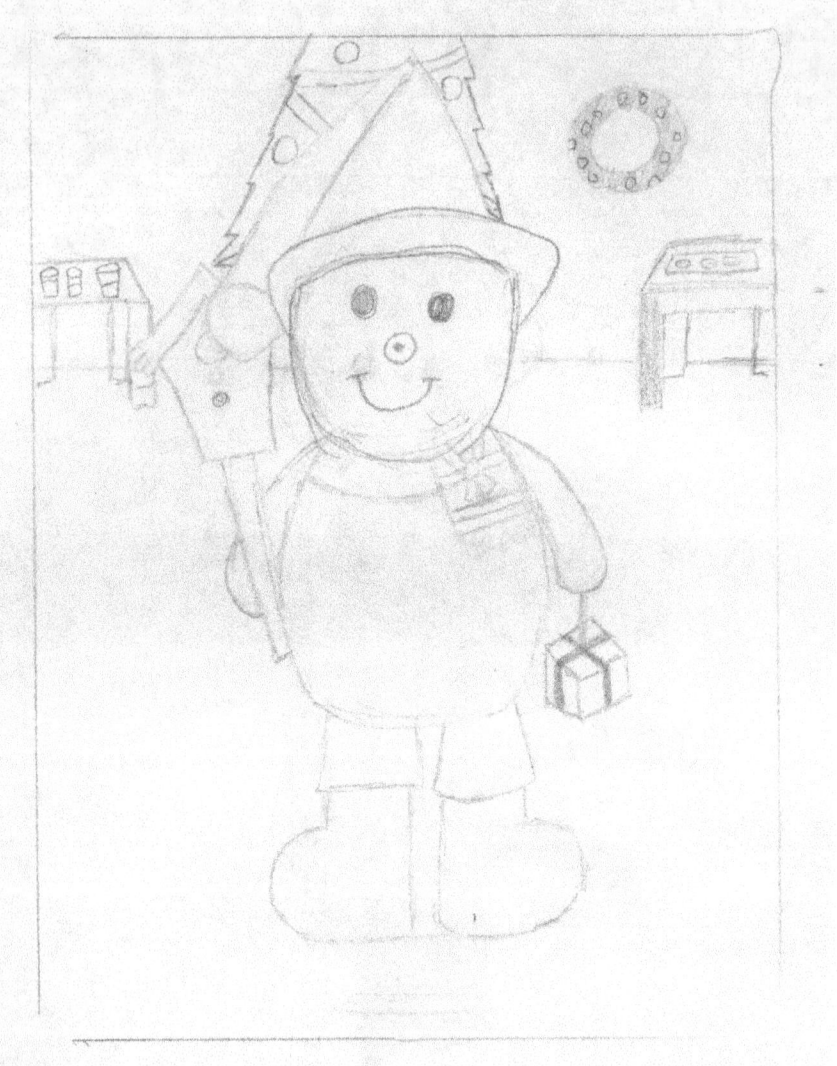

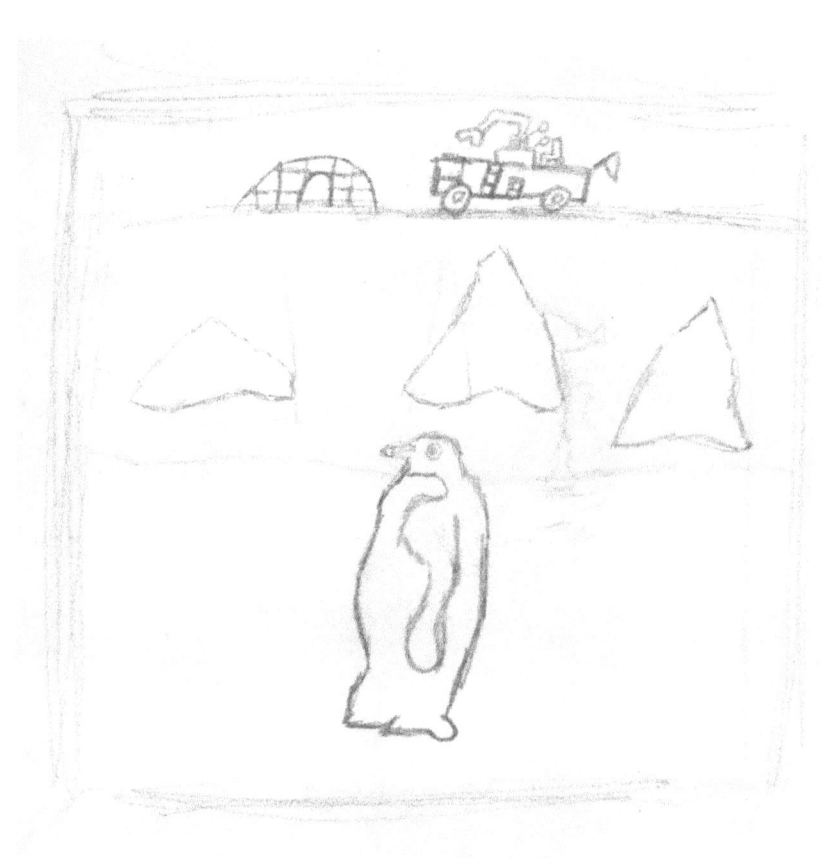

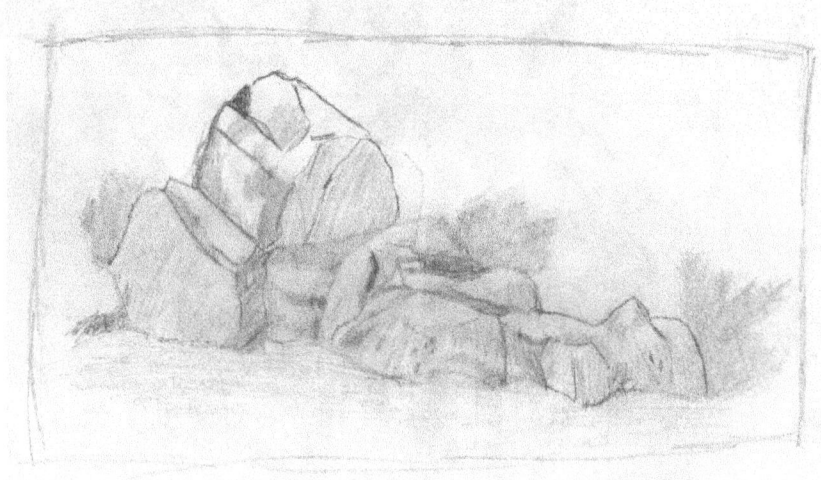

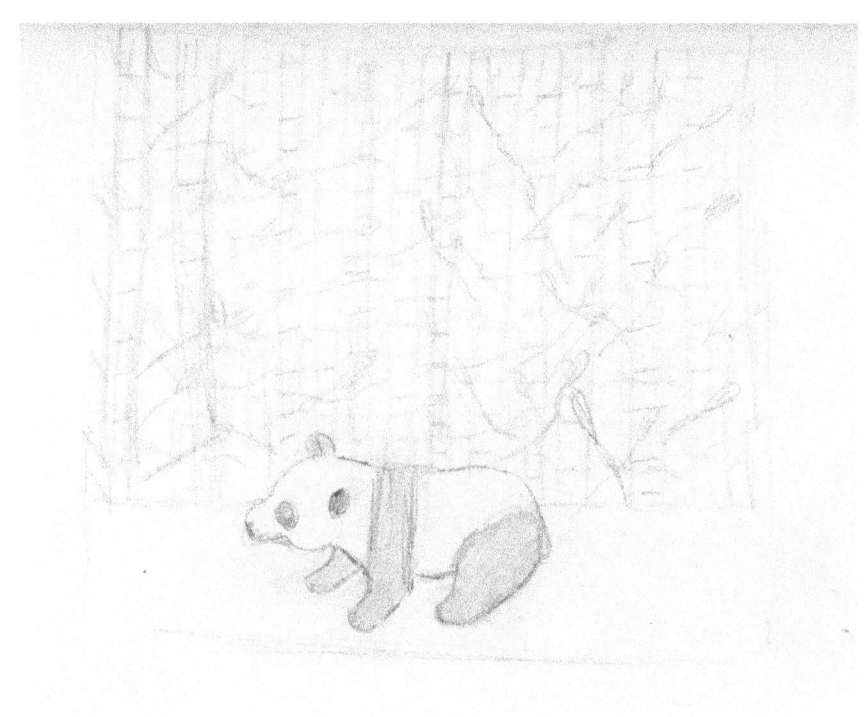

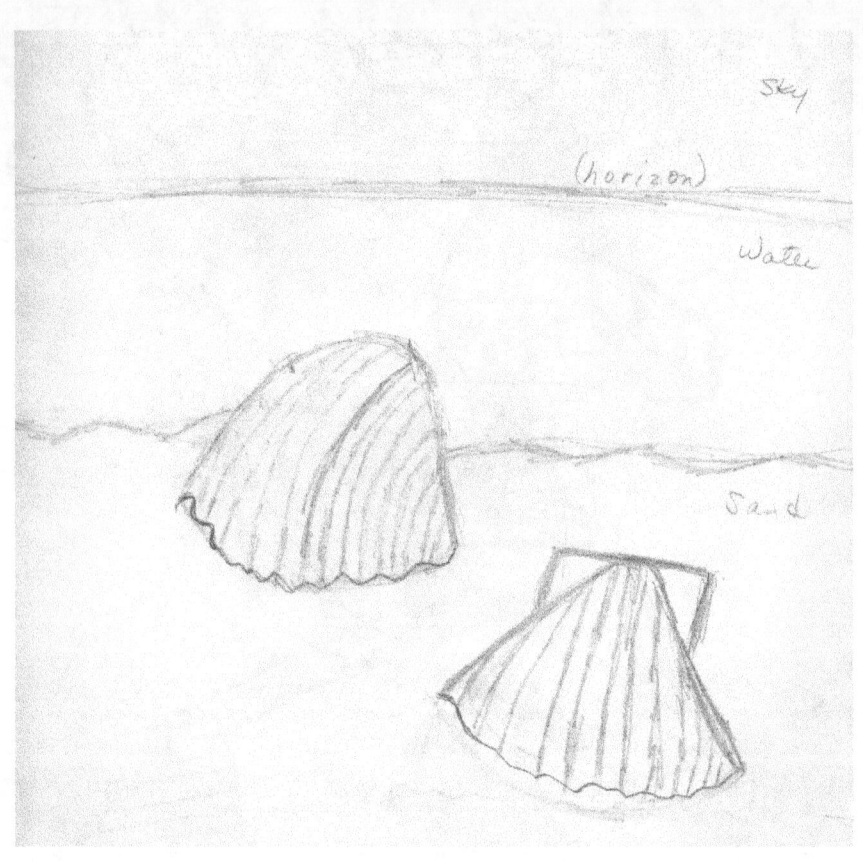

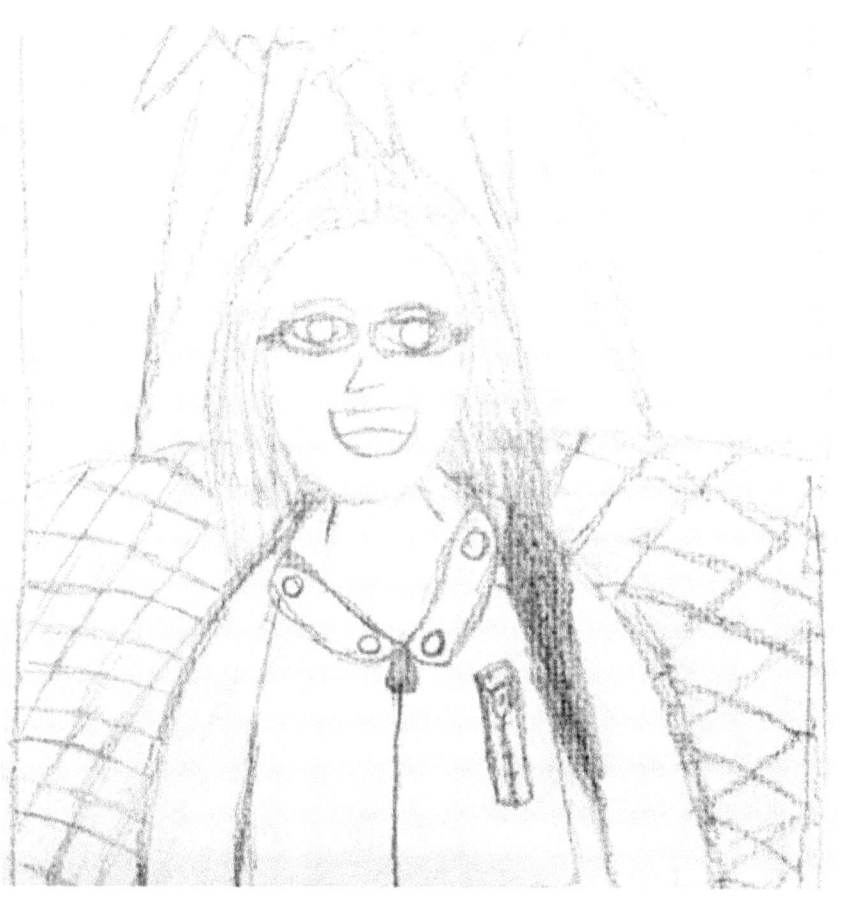

www.ingramcontent.com/pod-product-compliance
Lightning Source LLC
Chambersburg PA
CBHW072217170526
45158CB00002BA/637